See You 2-Maui
A Kid's Guide To Maui, Hawaii

Photography By John D. Weigand
Poetry By Penelope Dyan

Bellissima Publishing, LLC
Jamul, California
www.bellissimapublishing.com

ISBN 978-1-61477-038-1
First Edition

He puko'a kani 'aina.

A CORAL REEF HARDENS INTO LAND.

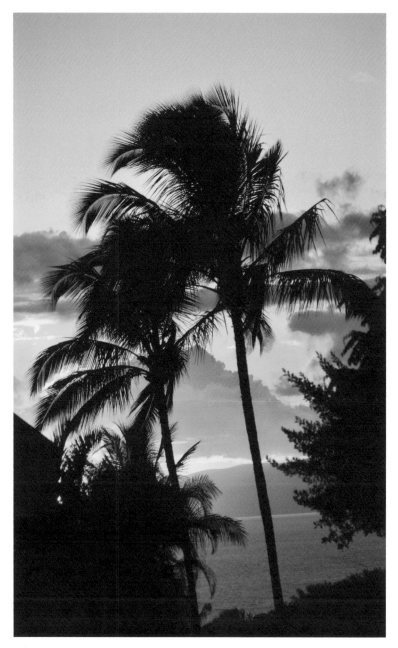

See You 2-Maui

Bellissima Publishing, LLC

Introduction

Native Hawaiians tell us how Maui got its name in the legend of Hawai'iloa, who was a Polynesian navigator who discovered of the Hawaiian Islands. According to the legend, Hawai'iloa named the island of Maui after his son, who was named after the demigod Maui. Maui is also called the "Valley Isle" because of the large isthmus between the northwestern and the southeastern volcanoes of Maui and the numerous large valleys carved into those mountains. In fact, Maui's landscapes are the result of a combination of the geology, the topography, and the climate of Maui; and each of the "volcanic cones" in the Hawaiian Islands (including Maui) is built of dark, iron-rich, quartz-poor rocks, poured out of thousands of vents as liquid lava, over millions of years. Maui is a "volcanic doublet," formed from two shield volcanoes that overlapped to form an isthmus between them. However, the main thing about Maui is its true Aloha spirit; and when you go to Maui, be sure to revel in it. Go native, hit the beaches, have a barbecue on the beach, visit the Maui Aquarium, sit on a surfboard in the warm Maui water, and taste a piece of sugar cane. Shop in Lahaina. Travel all around the island. Most of all, smell the sweetness of the flowers and bask in the light of the Maui sunsets! AND look for the FREE video that goes with this book ("The Deep Blue Sea") on the Bellissimavideo YouTube channel.

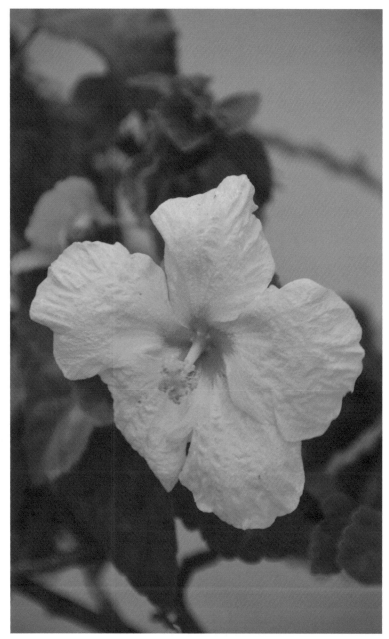

See You 2-Maui

Bellissima Publishinga, LLC

See You 2-Maui
A Kid's Guide To Maui, Hawaii

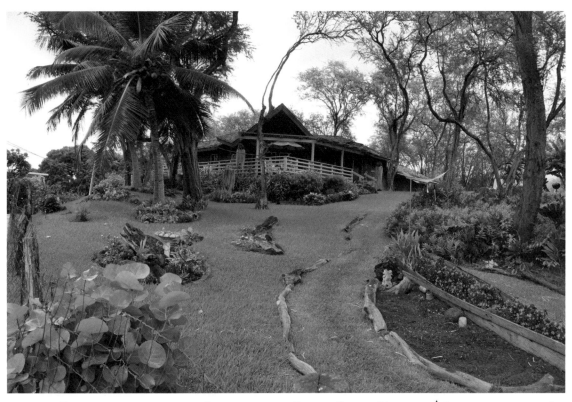

Photography By John D. Weigand
Poetry By Penelope Dyan

In Maui there are gardens,
lush, colorful and green.
They are the most beautiful gardens
I have probably ever seen.
Flowers, especially, smell quite sweet,
and eating pineapple in Maui
(on your lanai) a VERY delicious treat!

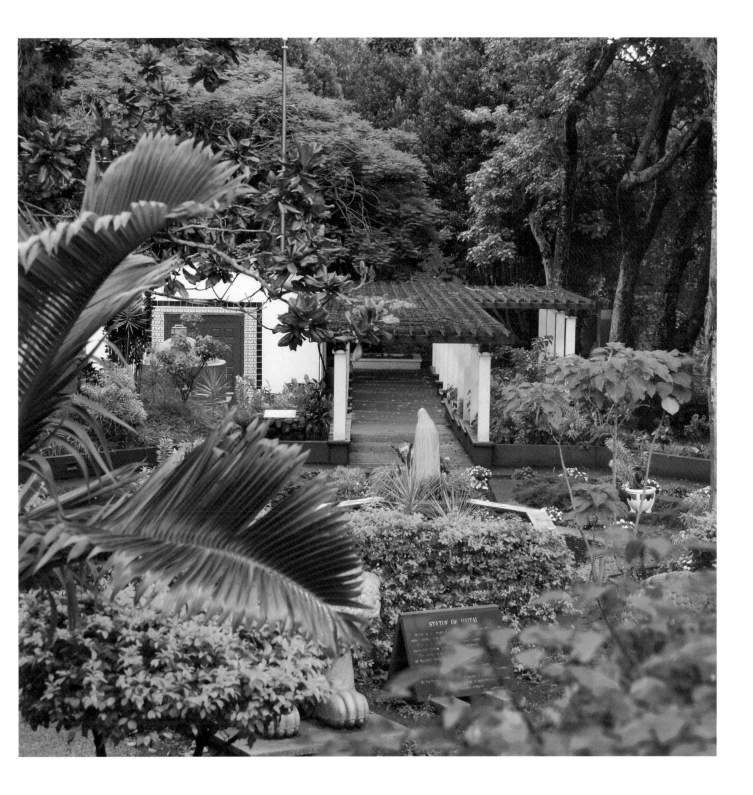

You can walk down the stairs,
and carefully cross the street.
Into the ocean you can plop your feet!
Right there you can splash and play.
In Maui it's ALWAYS a sunshiny day!

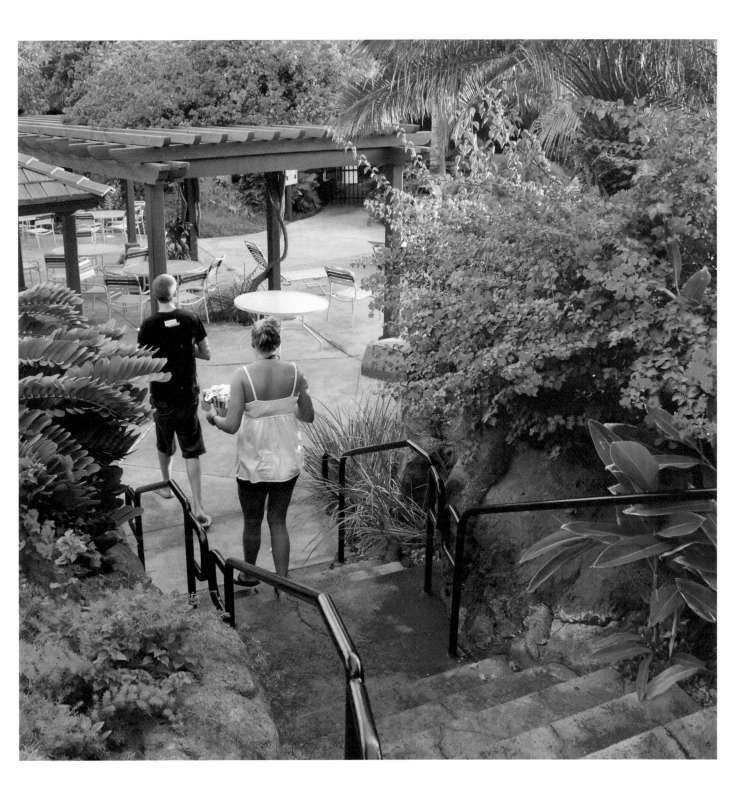

There it is! The ocean blue!
It waits for me. It waits for you!
So go ahead and down the beach run.
The Maui Isle is meant for fun!

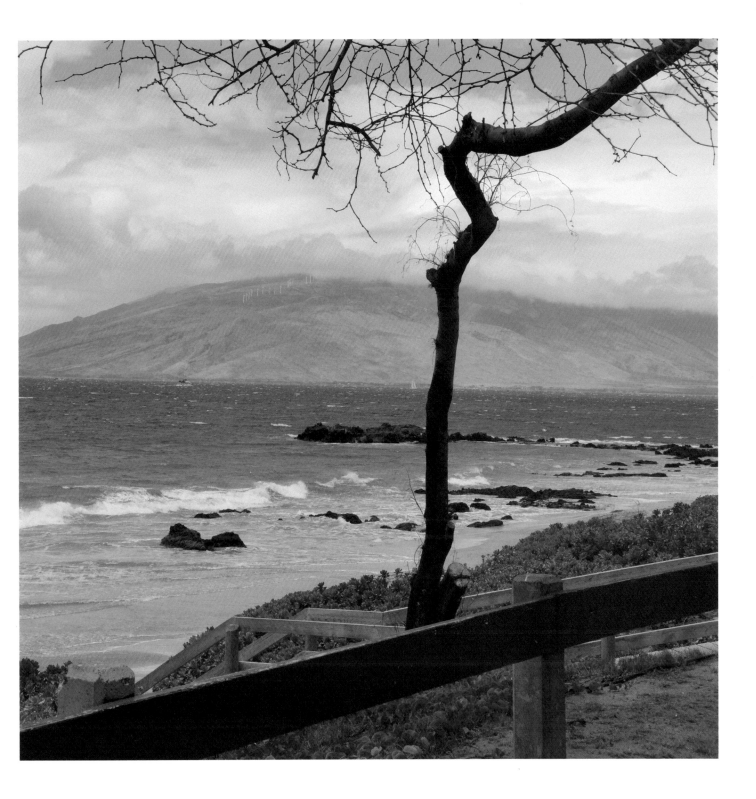

You can sit on a surfboard
with some kids and your dad,
and you can have the best fun
that you've ever had!

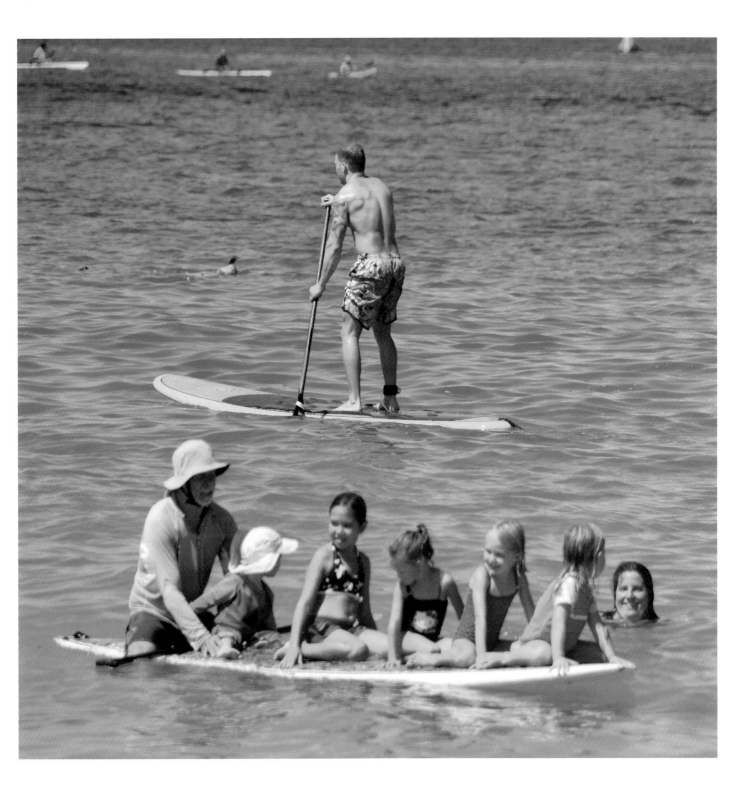

You can look for whales, dolphin
and turtles from the deck of a boat,
as you eat a snack, have a drink,
and then right by them bob and float.

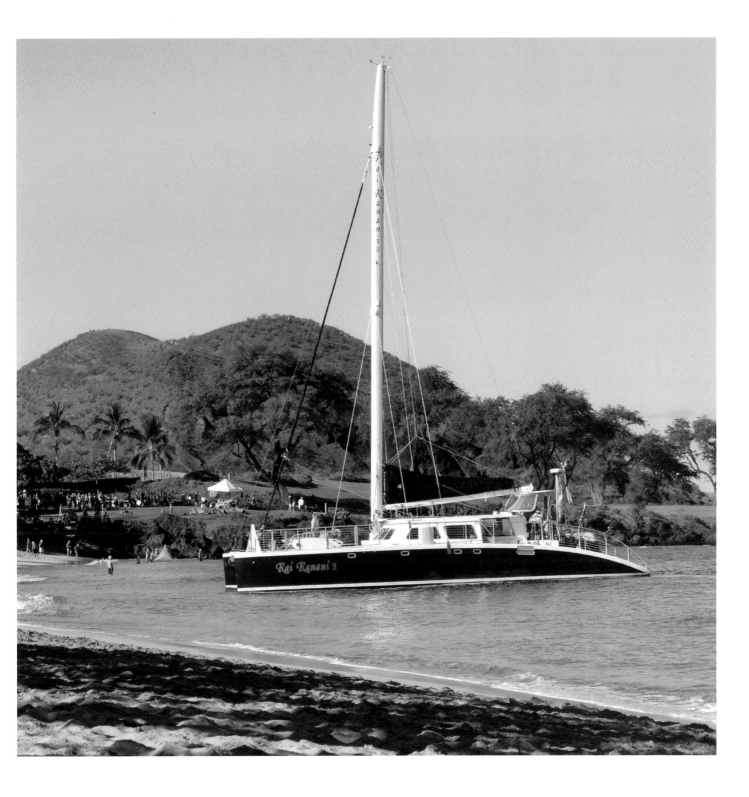

Hop aboard the Sugarcane train!

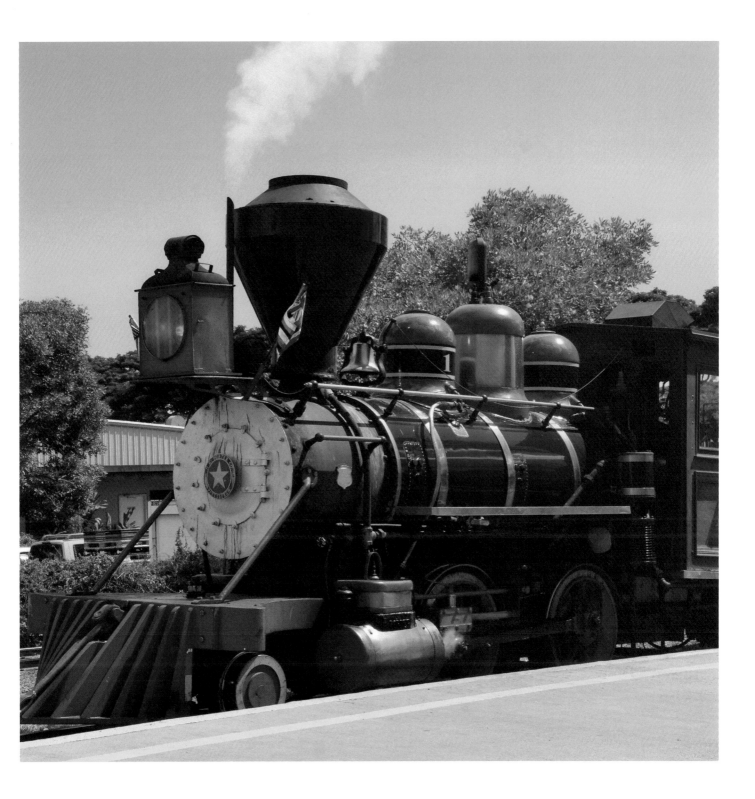

Take a look at some sugar cane!

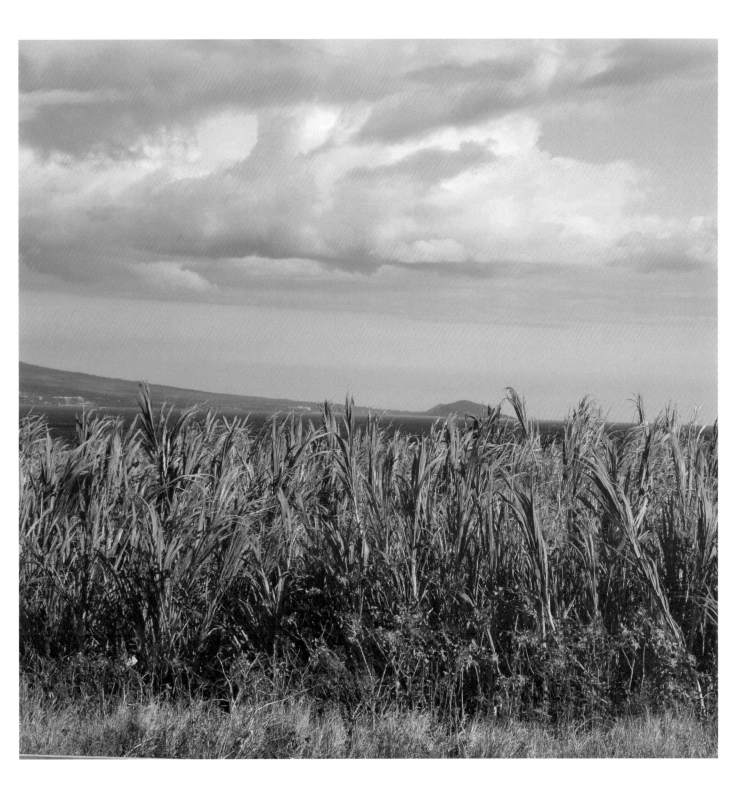

See the old sugar cane mill.
(It is old, but never still. . .)
When the smoke stack puffs
you can smell burnt sugar in the air.
And the smell of sugar is everywhere.
The smell wrinkles your little nose.
(It's NOT as if you smelled a ROSE!)
It makes you hungry, and you think,
"I'd LIKE a snack now, AND a drink!"

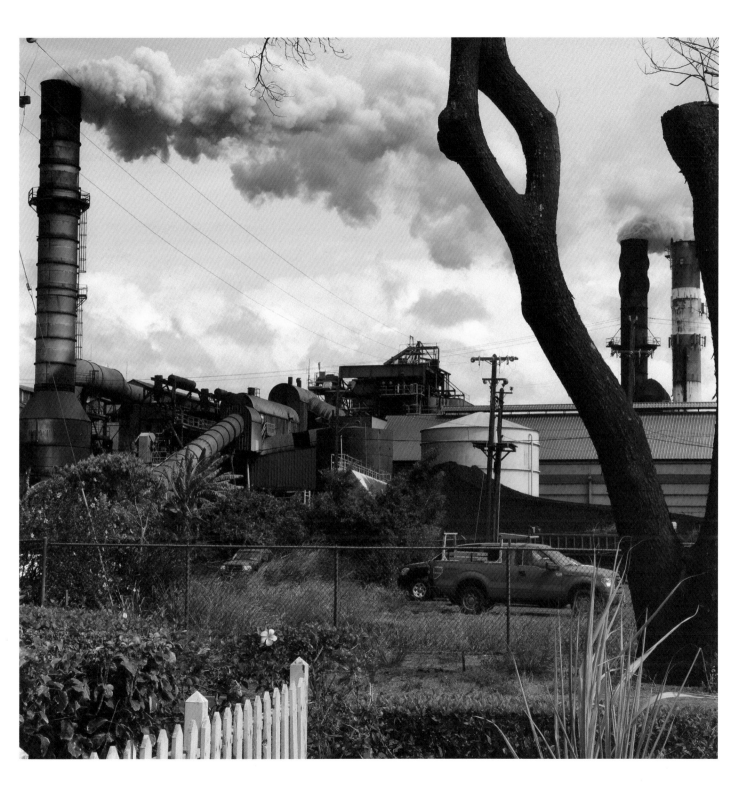

You go into Lahaina town
and you find a feathered fella,
protected (from the sun) in his cage
by a polka dotted umbrella!

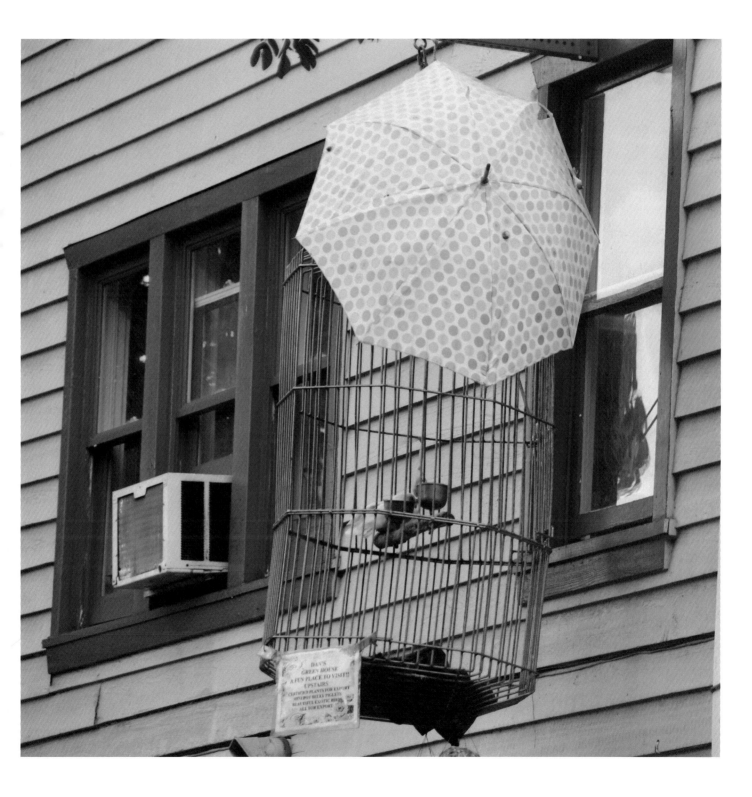

As you leave the bird's outdoor cage
There's a sharks' teeth store!
(It's all the rage!)
You purchase one shark tooth,
and then you buy TWO more!
You really like this shark tooth store!

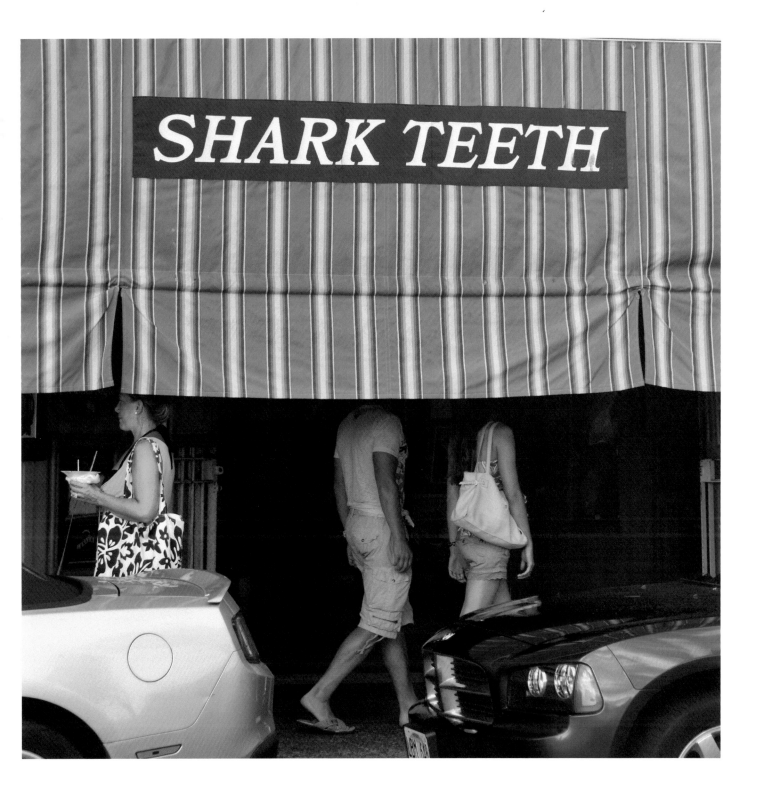

You keep on shopping down the street.
Then you go back to the condo to eat!
You hop right into your rented car.
You're VERY hungry, but it isn't far.

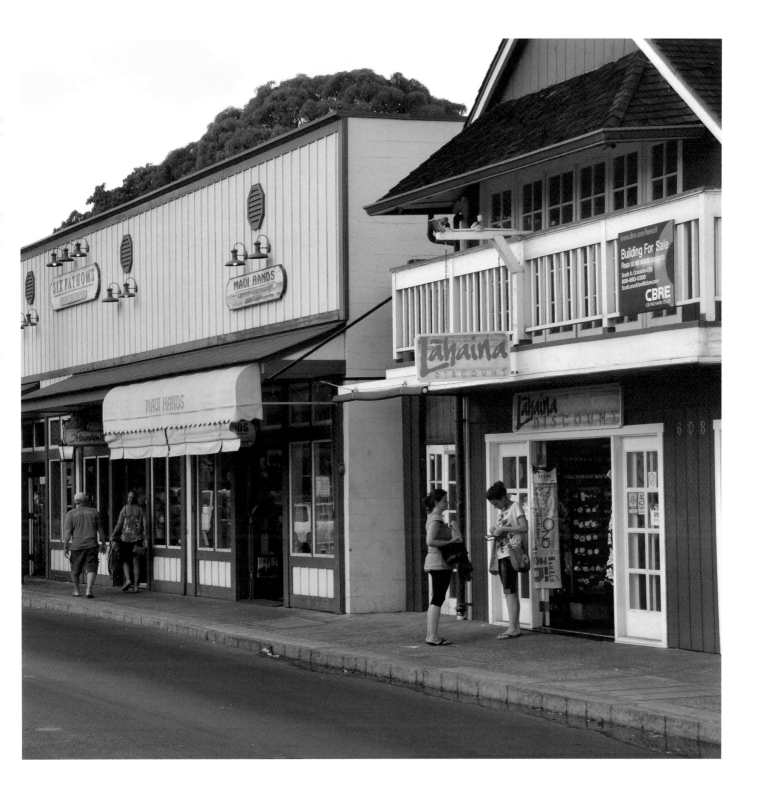

After dinner you go outside.
From Maui's sunset you cannot hide.
It has been a lovely day,
of fun and shopping and lots of play.
You sit and make castles in the sand.
Your mother looks AND says,
"How VERY grand!"
Soon you'll go up and crawl in bed,
and upon a soft pillow lay your head.
You'll drift off and into sleep,
and dream the dreams of oceans deep.
You're happy tomorrow is another day,
to laugh and sing, to swim, to play!
You can't hardly even wait.
You decide that you will not sleep late!

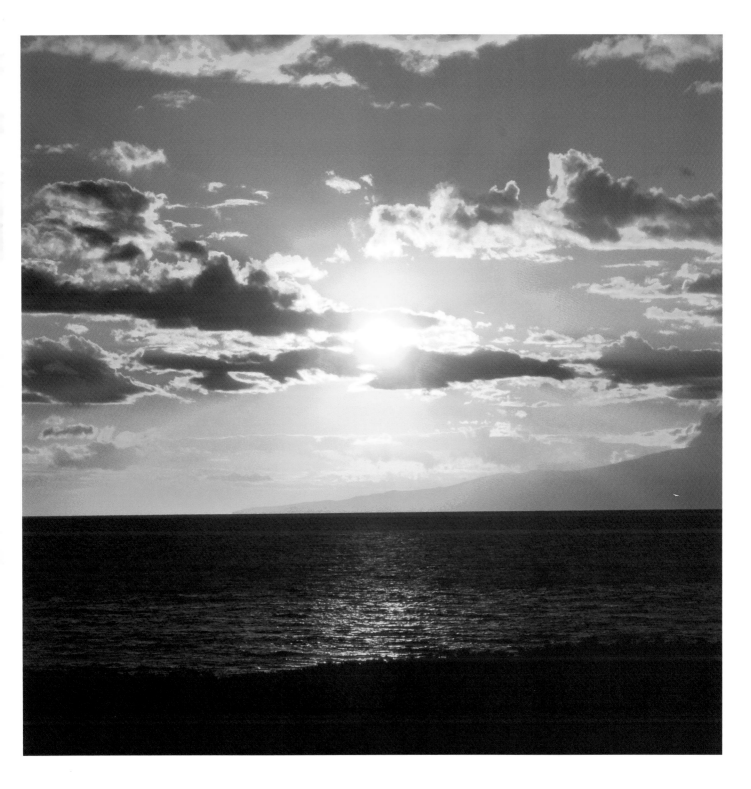

*He lawai'a no ke kai papa'u, he pokole ke aho;
he lawai'a no ke kai hohonu he loa ke aho.*

A FISHERMAN OF SHALLOW SEAS USES ONLY A SHORT LINE,
WHILE A FISHERMAN OF THE DEEP SEA USES A LONG LINE.

You will reach only as far as you aim and prepare yourself to reach.

CPSIA information can be obtained at www.ICGtesting.com
Printed in the USA
BVIW12n1620310718
523156BV00008B/156

* 9 7 8 1 6 1 4 7 7 0 3 8 1 *